WINGS
OVER NEW ORLEANS

UNSEEN PHOTOS OF PAUL AND LINDA MCCARTNEY, 1975

WINGS
OVER NEW ORLEANS

JOHN TAYLOR

PELICAN PUBLISHING COMPANY
Gretna 2015

The word "Pelican" and the depiction of a pelican are
trademarks of Pelican Publishing Company, Inc., and are
registered in the U.S. Patent and Trademark Office.

Library of Congress Cataloging-in-Publication Data

Taylor, John, 1953-
 Wings over New Orleans : unseen photos of Paul and Linda
McCartney, 1975 / by John Taylor.
 pages cm
 ISBN 978-1-4556-2034-0 (pbk. : alk. paper) — ISBN 978-1-4556-
2035-7 (e-book) 1. McCartney, Paul—Portraits. 2. McCartney,
Linda—Portraits. 3. Rock musicians—England—Portraits. I. Title.
 ML410.M115T39 2015
 782.42166092'2—dc23
 2014036630

Printed in China
Published by Pelican Publishing Company, Inc.
1000 Burmaster Street, Gretna, Louisiana 70053

To my wife, Janet; my daughters and their husbands, Jamie and Jacob Stephens and Rachel and Josh Schmidt; and my grandchildren, Barrett, Ethan, Austin, and Taylor

CONTENTS

INTRODUCTION

In January of 1975, Paul and Linda McCartney along with Wings came to New Orleans to record their new album at Sea-Saint Studio, located in a quiet neighborhood known as Gentilly. In the small parking lot of the studio, a group of people had the rare opportunity to meet and talk to Paul and Linda McCartney. To many of them, this will always stand out as some of the best times in their lives.

I was one of those fortunate few. I met Paul and Linda almost every day that they came to the studio. I took pictures, got autographs, and got to talk to them on many occasions. That will always stand out as one of the most exciting times in my life.

As the years passed, I told the story less and rarely pulled out the pictures to show. Thirty-eight years later, I read an ad on Facebook that asked, "Have you ever met a Beatle?" I sent one of my pictures, and the person who ran the ad was thrilled.

We began to communicate online, and I sent a few more pictures and told my story. To make a long story short, the man who ran the ad, Dean Johnson, was a singer/songwriter near Liverpool, England. He was writing a book containing pictures and stories of people who had met a member of the Beatles. The publication featured seven of my photographs.

That was when I realized that there was an interest in my pictures and the stories of the people who were there when a former Beatle was recording in New Orleans.

It has been several decades since I met Paul. It is time to share these pictures and stories with the rest of the world.

A LITTLE ABOUT ME

I was born in 1953 in New Orleans, Louisiana, to John Taylor and Lottie McGovern Taylor. I have four sisters, Charlotte, Barbara, Brenda, and Lisa, and one brother, Kenneth. I had a very happy childhood in Gentilly, and like most boys back then, I would play Cowboys and Indians, Tarzan, and, of course, Superman, jumping off my bed with a towel "cape" tied around my neck. My good friend, Louis Kahl, lived about two blocks from my house. We shared the same birthday, but I was a year older.

On my tenth and his ninth birthday, I got a bow and arrow set with the rubber tips, and Louis received a guitar. About a week or two later, he was already playing songs. I had to get a guitar; I was drawn to it. My parents were able to get me one from a cousin who wasn't using his. From that day forward, it was me and the guitar. Louis and I started taking lessons together, and as time went on, we got pretty good. Over the years, we have played in several bands together. He still plays professionally, and to this day, I make part of my living playing music.

In 1964, my older sisters were all excited about a group called the Beatles. The band was scheduled to be on "The Ed Sullivan Show" one Sunday. I didn't know anything about this group, but if they played guitars, I was going to check them out. Sunday finally came and my family gathered around

the TV. I remember Ed Sullivan announcing, "Here they are! The Beatles." To this day I have never seen anything like this. Girls were screaming. These four guys with guitars and drums and really weird haircuts were producing this sound that was so incredible. There was so much energy flowing from the TV, and I was hooked. Everything was perfect: their suits, their hair, even their guitars. I particularly liked the guitar shaped like a violin. I had never seen anything like that before, and it was so cool.

I used to take the bus home from school and would have to walk about six city blocks to my house. I would take a shortcut through a shopping center along the way. In the middle of this shopping center was a music store, and in the window was a violin bass guitar like Paul's.

This is where I would take a break from walking. I would stand and stare at that guitar; I just thought it was so cool. After a few weeks of this, the lady who worked there came out and said, "Son, every day you come and look at that guitar. Won't you get your parents to buy it for you for Christmas?"

I told her it was probably too expensive, and I didn't play bass. She said it was only eighty-five dollars. It was a Japanese copy of the German Hofner that Paul used.

I asked if she could order one that was a six-string guitar, and she said they only made this style as a bass. I decided that I wanted it anyway. I told my parents I wanted it for Christmas. I begged.

About a week later, the guitar was gone from the window. I went into the store and they told me that a little boy had come in with his dad and they had bought it. I asked if they

could order another guitar and explained that I just about had my parents talked into it. They told me that it was the last one. It came by mistake, and they could not get any more. I left heartbroken and depressed. Then Christmas came, and I got the bass! My father wanted it to be a surprise, so everyone had told me a big fib. I traded five Beatles albums for three months of bass lessons, and I have been playing ever since.

In 1974, I had my first opportunity to see one of the Beatles in person. I couldn't believe it! George Harrison was coming to the LSU Assembly Center in Baton Rouge. Tickets were eight dollars.

November 26 finally arrived, and I was there in my seat. On the stage were all of George's guitars, even Rocky, the psychedelic Fender Stratocaster that he hand-painted and used on *Magical Mystery Tour.* After the opening act, George appeared onstage and broke into one of his songs. I was just blown away that I was watching and listening to one of the Beatles. My seat was too far away to get a picture with my small camera, so I walked toward the stage and was able to sneak one snapshot of George.

The concert was great. George's voice was hoarse, but I didn't care—I was thrilled to finally see a Beatle. This was a big event in my life. I could never have dreamed what was going to happen in less than two months.

I learned that Paul McCartney was coming to New Orleans in 1975 to record his new album with Wings. I had to find out which studio he would be at, so I could maybe get to see him in person. I was sure there would be bodyguards and police, and they would probably sneak him in through a side entrance.

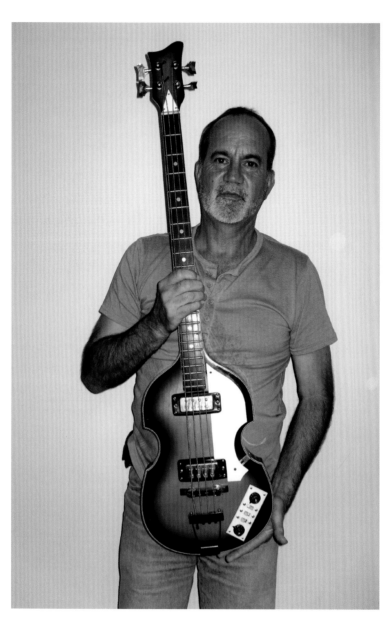

Me with my first Beatles bass

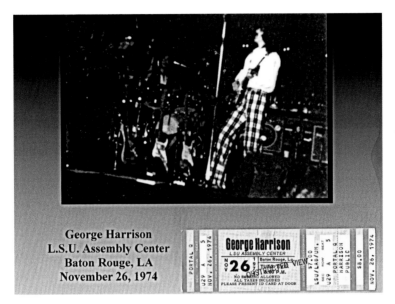

Picture of George Harrison in Baton Rouge, with ticket

Sea-Saint Studio was in my neighborhood of Gentilly. I decided I would check there first. So one morning I drove to Sea-Saint Studio and pulled into the small parking lot. The studio was converted from a house, and the parking lot only held four or five vehicles.

My plan was to knock on the door, but I had to figure out how I was going to ask whoever answered, "Is this where Paul McCartney is coming to record his album?" I sat there for a few moments and finally decided that this was not a good idea. I started my car, and as I was putting it into drive to take off, a car pulled up next to mine.

I glanced over to see who it was, and I couldn't believe my eyes. In the car next to me was Paul in the driver's seat and Linda in the passenger seat. They looked over, smiled, and waved.

Now try to understand. There were no bodyguards, no police, no limousine—just Paul, Linda, and me. One minute later, I would have been down the street, and this would not have happened.

I turned my car off, got out, and walked toward Paul and Linda as they were getting out of their car. Paul came up to me, shook my hand, and asked, "How are you this fine morning?"

I said, "I'm fine. You are really all right."

He replied, "I hope so by now."

This is the person who has had the biggest influence on my life and my music—the reason that I am a bass player—and here I was standing there talking to him. I can't explain how I felt. This was where I was going to be every day for the next three months. The next day I arrived at the studio around the same time and noticed two guys parked in front of the house next door. I went over and asked them if they were there to see Paul. They said yes. I told them what happened the day before and that Paul should be arriving soon. We became friends.

Paul and Linda arrived not long after that. We took pictures and spoke to Paul for at least fifteen or twenty minutes. None of us is a professional photographer, but we did get a lot of really great pictures of Paul and Linda. Keep in mind that these photos were taken with a Kodak Instamatic, 110 film, back in 1975. Some of the photos or film got damaged over the years. However, these photos appear in this book because they are still a part of this history.

In the following pages you will read other remembrances of these events and see photographs from that time. I hope you enjoy this look back at a unique moment in New Orleans music history.

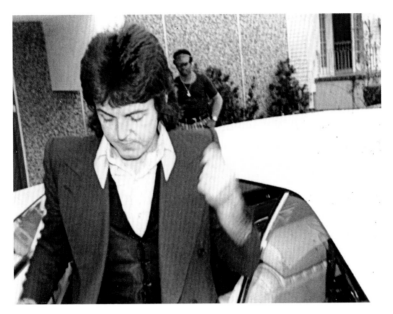

Paul arriving at the studio

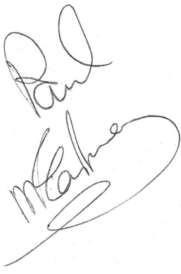

Paul signed the back of my business card, from my job at a nearby car dealership.

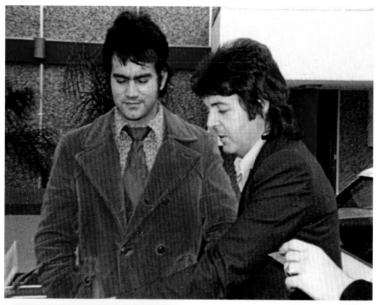

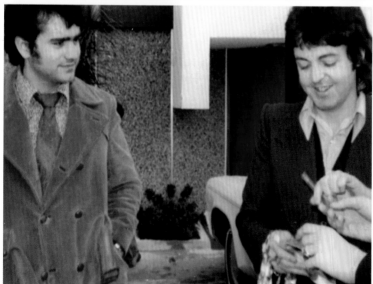

Me and Paul

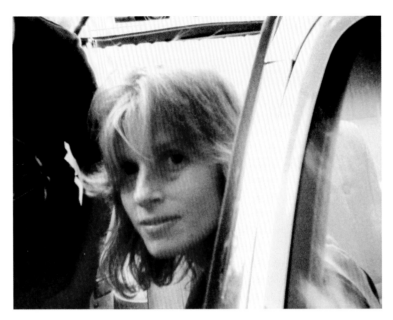

Linda strikes a pose for me

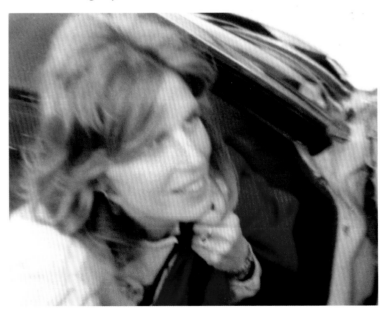

Linda getting out of the car

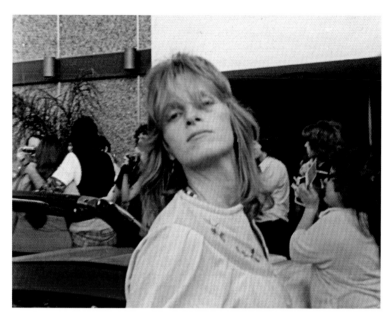

Linda poses for me

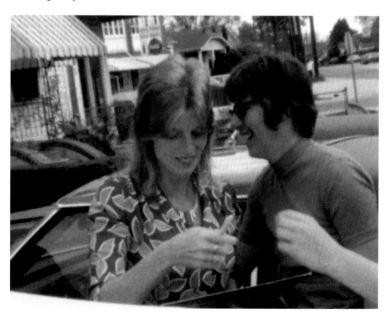

One of the studio engineers talks with Linda

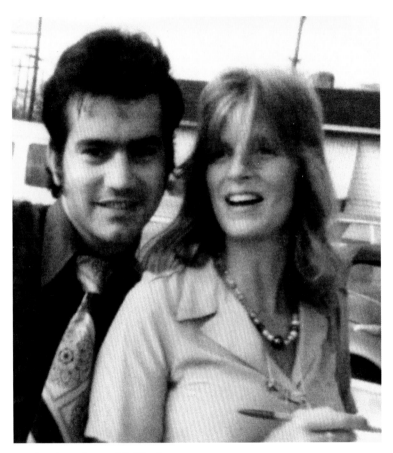

A nice shot of me with Linda

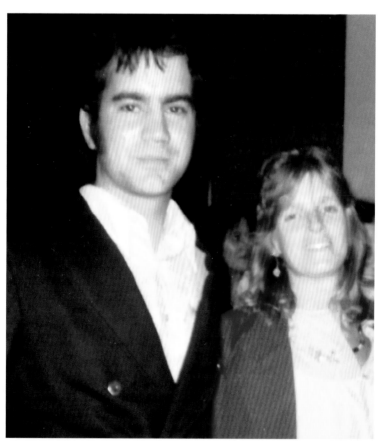

Me with Linda

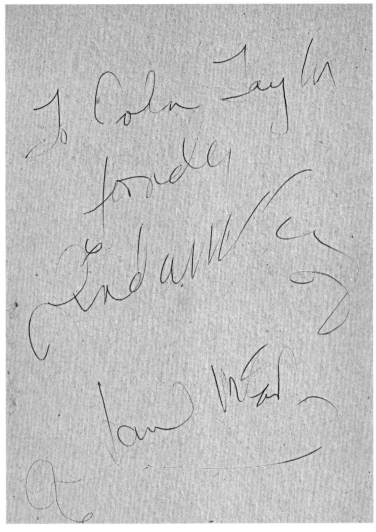

In this autograph, Linda wrote, "To John Taylor fondly." She signed her name, then Paul signed his.

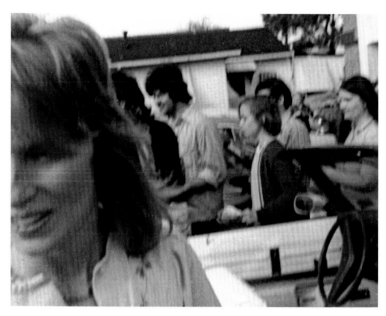

Linda, with Paul and fans in the background

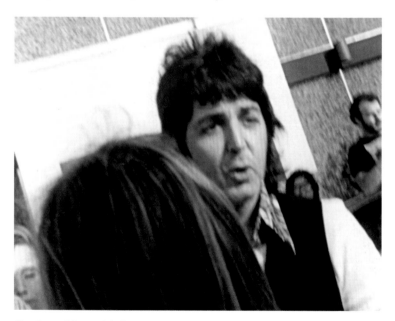

Paul speaking with fans

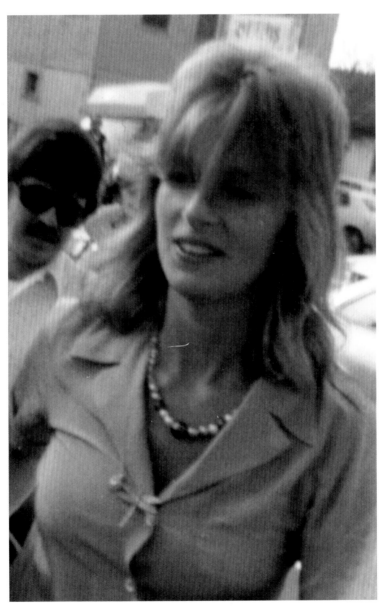

Linda arrives and greets fans

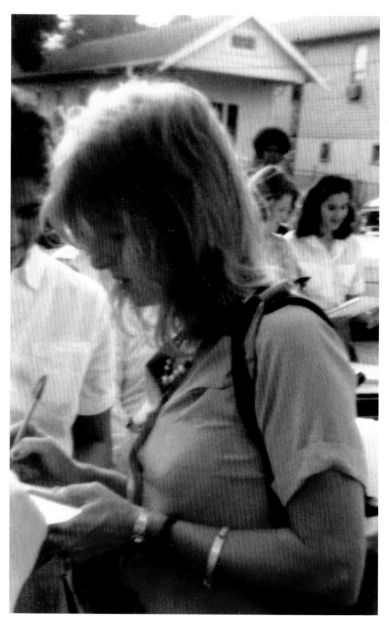

Linda signs autographs

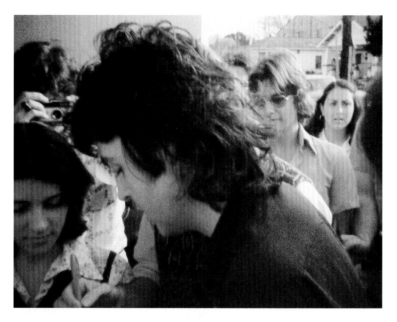

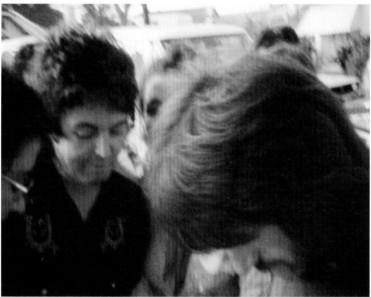

Paul signs autographs

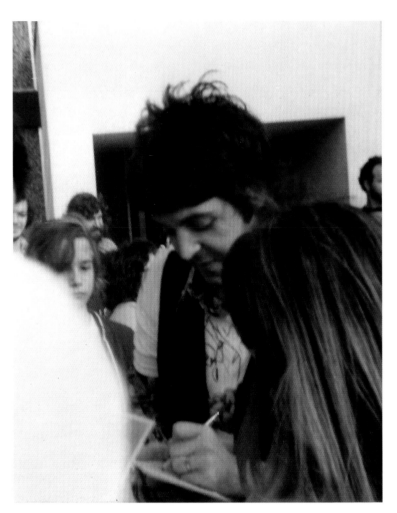

Paul with fans

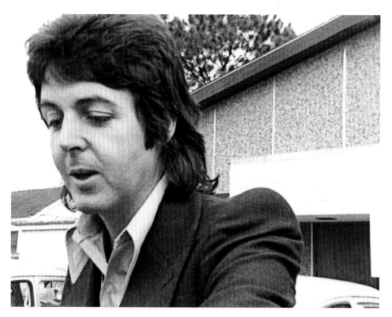

Paul hands his autograph to a fan

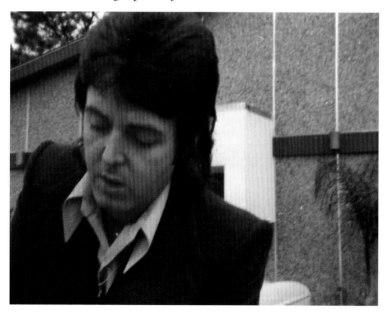

Paul signs autographs

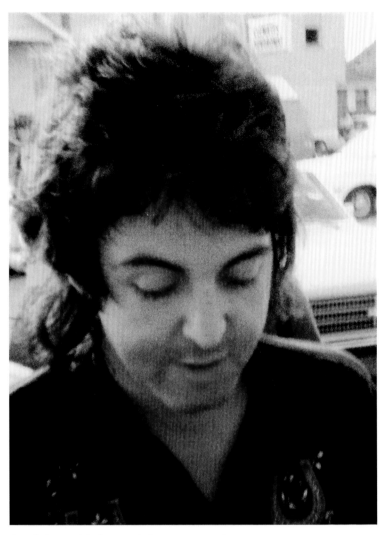

Paul chats with fans and signs autographs

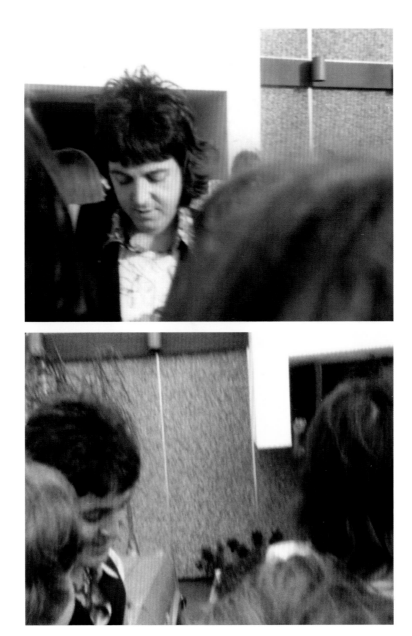

Paul spending time with fans

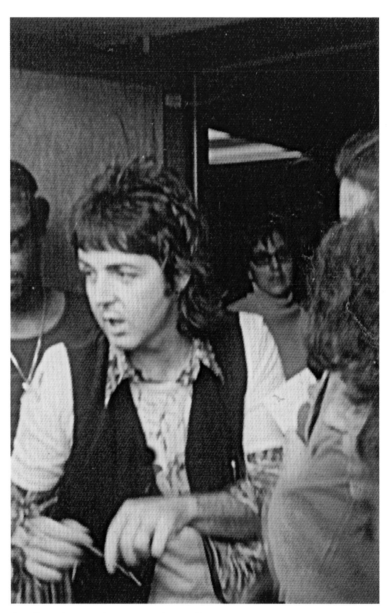

Paul getting ready to enter the studio

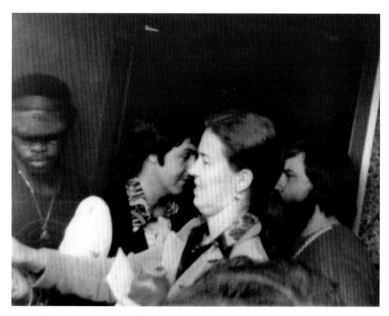

Paul in the doorway of the studio

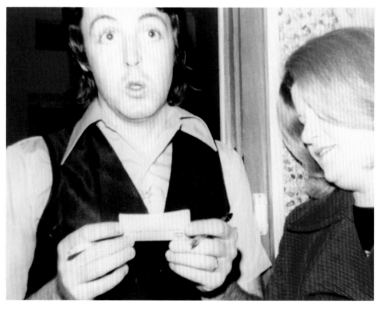

Paul in the studio doorway, signing autographs and speaking with fans

Paul and Linda enter the studio

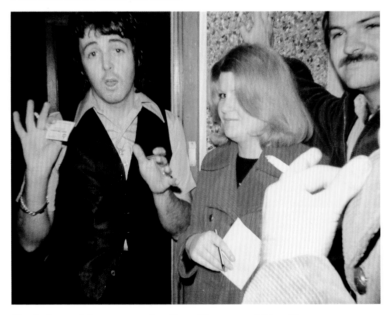

Paul chats with my co-worker Steve Rogers and his wife

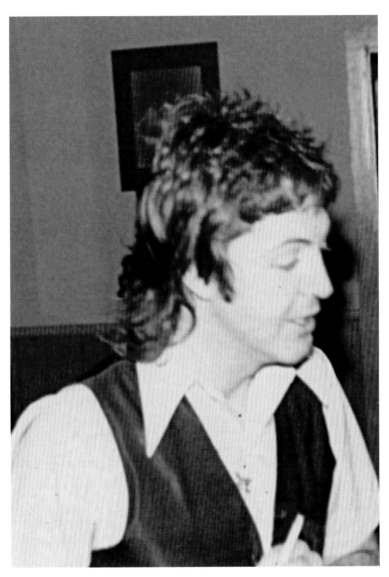

Paul in the doorway, speaking with us

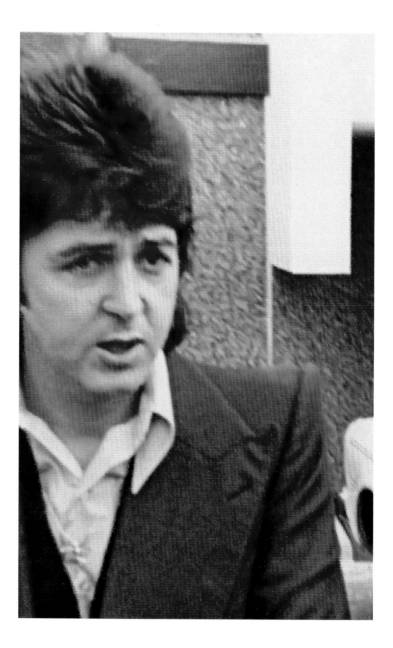

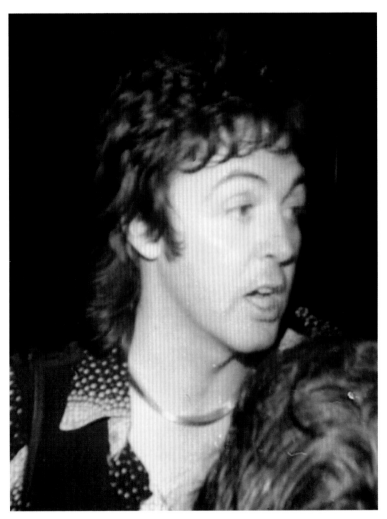

A great shot of Paul

Linda posing

Paul getting in the car to leave the studio

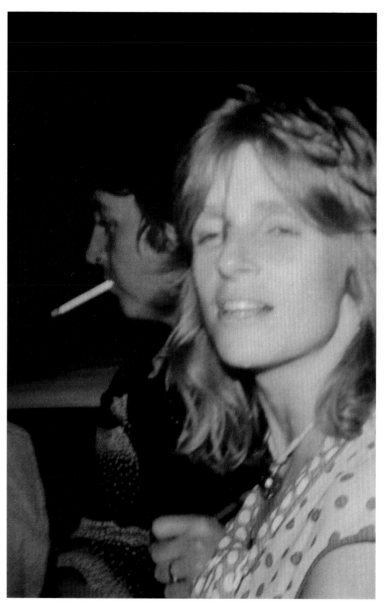

A nice shot of Paul and Linda

Linda getting in the car

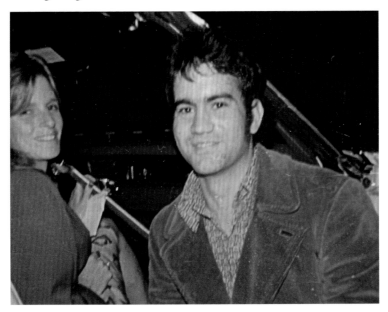

Linda and me

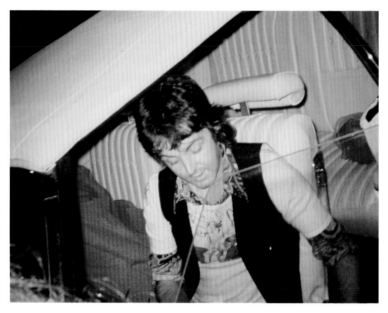

Paul signs an autograph before leaving

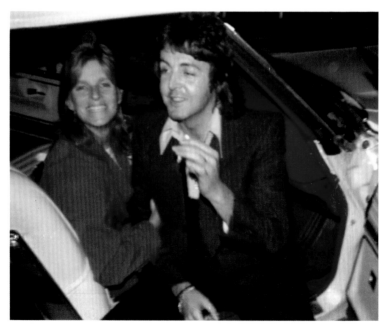

Paul poses with Linda

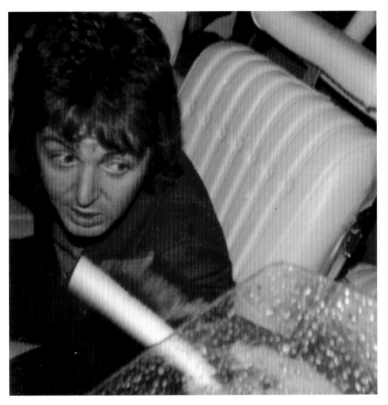

Paul leaving the studio

WORD AROUND TOWN

Susan Baldwin Amato

It was in September of 1964 when I first got a glimpse of the band that literally rocked the world. I was only eight years old at the time but completely smitten with the Beatles. They were scheduled to play in New Orleans at City Park Stadium, and I knew they would be passing right in front of my home in order to get to the park. My sisters and I stood outside for hours, determined not to miss that limo carrying the four young men that every girl in the world would love to see. And, oh my, I nearly fainted at the sight of that limo as it came down the street in front of my very eyes! I don't think I slept that night at all.

Fast forward to 1975. I was now nineteen years old, and word around town was that Paul and Linda would be recording a Wings album at Sea-Saint Studio, which was only a few blocks from my home. I'll never forget sitting outside the studio with some close friends, waiting for that limo once more. This time would be different. It would stop, and I would actually be there to see Paul close up, live and in person.

Gosh, I don't know who was more excited, my friends or me. And before my very eyes I watched Paul and Linda stop to tell us hi and even take time to give us autographs that day.

We took pictures and then waited and waited in hopes of seeing them leave the studio too. We did this for the next few months.

Every afternoon, we sat outside the studio and waited for the band to pull up. We watched food being delivered and waited for a glimpse of Paul. But I got so much more than that, because after a while, Paul would come up and greet me by name! He would say, "Hello, Susie," in that beautiful British accent, and it melted my heart. Paul was so handsome. I loved his long stylish hair, his beautiful bright eyes . . . okay, I'm getting a little off track, but I'm sure you get the picture. I thought I was madly in love with Paul McCartney! Of course, Linda was always right there with him, but it never stopped me from dreaming.

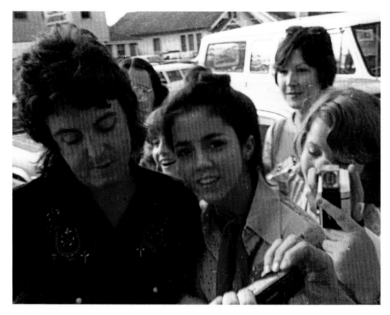

Susan Baldwin Amato and Paul

It's been many, many years since that time back at Sea-Saint Studio, yet my memories are as fresh as the day I first saw him. What an amazing opportunity I had to meet and talk with someone as famous as Paul McCartney, and I've still got the pictures to prove it.

IN THE NEIGHBORHOOD

Danny Gaudin

I was a *huge* Beatles fan. So when I heard that Paul McCartney and Wings were going to record the *Venus and Mars* album at Sea-Saint Studio, in my neighborhood, I couldn't wait to see him. I was there the day he arrived and waited for hours.

Finally, he pulled up in a big white convertible with Linda and their kids. Everyone ran up to the car and was taking pictures. He was very friendly and even stayed outside for a few minutes signing autographs and letting people take photographs.

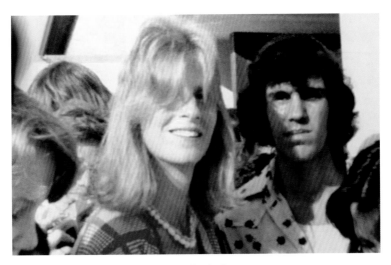

Danny Gaudin's photo of him and Linda

I, along with others, was outside the studio many evenings after school, waiting to get a glimpse of him and maybe some more pictures. I was finally able to shake his hand and get his autograph, as well as Linda's. She was also very cool, coming out at night sometimes and talking with the people who were waiting around. I met Denny Laine and Jimmy McCulloch too. It is something I will always remember.

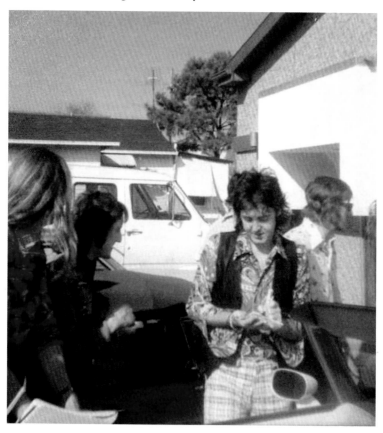

Paul signing autographs as Denny Laine looks on, taken by Guy Duplantier

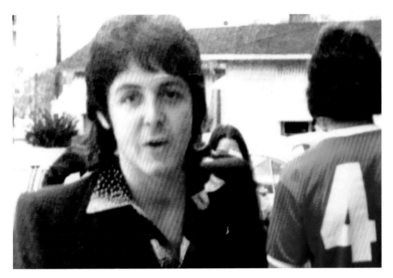

Photo of Paul, taken by Danny Gaudin

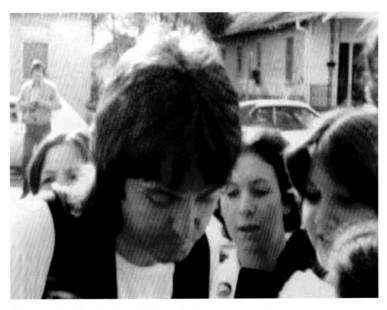

Danny Gaudin's photo of Paul signing autographs

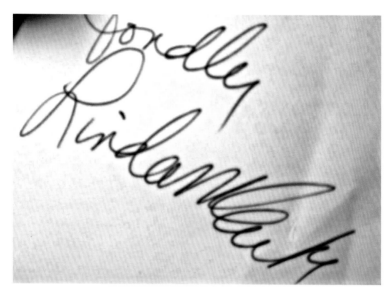

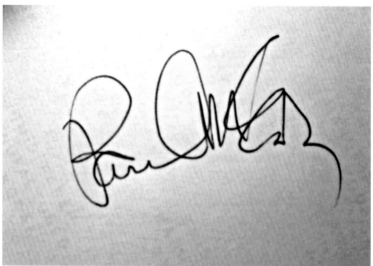

Autographs for Danny Gaudin

Denny Laine, taken by John Taylor

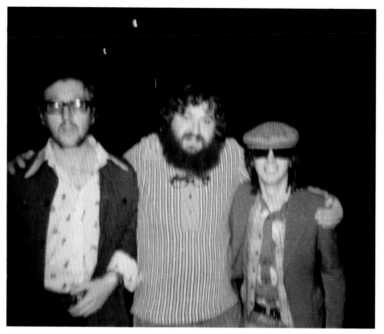

Allen Crowder of McCartney Productions, studio co-owner Marshall Sehorn, and Wings guitarist Jimmy McCulloch, taken by John Taylor

I WAS SEVENTEEN

Guy Duplantier

In February 1975, I was seventeen years old. Paul McCartney and Wings were in New Orleans recording the *Venus and Mars* album, their follow-up to *Band on the Run*. Of course, we didn't know that would be the album's name at the time. Being the huge Beatle fan that I was (and still am), I was determined to meet Paul. As luck would have it, the album was being recorded about ten blocks from my high school.

I remember the first time I saw him. I guess you always remember the first time. It was late one Friday night, or rather early one Saturday morning, maybe three o'clock. Three of my friends and I had outlasted a few other people (since it was early in the "sessions," a crowd had not yet amassed). We were the only four left. Paul and Linda walked out. I was standing by the driver-side door of the white convertible he drove during his entire stay. Paul walked right up to me, put out his hand to shake, and asked me how I was doing this night. I shook it, of course. But I literally could not speak. He could not have been nicer, sensing my trembling. He wished me a good night, then he and Linda got in the car and drove off.

After that night, I was there every day after school for the entire duration of his recording. He would arrive at Sea-Saint

most afternoons right around three o'clock—just in time for
me to catch him driving up. One day both he and Linda signed
the inner sleeve to my *Band on the Run* album, a memento
I still cherish to this day. I remember that white convertible
like it was yesterday. But most of all I remember how utterly
gracious he was, day in and day out, taking time to greet the
growing crowd and signing autographs for what seemed like
an eternity. I was able to get extremely close (as you can see in
my pics). I took many photos of him each day.

I remember one of those days was a Monday. The night
before, there was a special on CBS commemorating the eleventh
anniversary of the Beatles' first appearance on "The Ed Sullivan
Show" (it being February and all). Anyway, as Paul signed

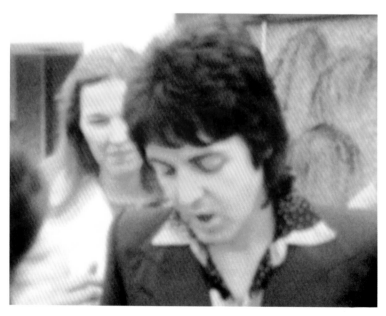

Close-up photo of Paul, by Guy Duplantier

autographs and posed for pictures, I literally got right next to him—shoulder to shoulder. I asked him if he had seen the special, and he said he had and it "was something." I felt like Chris Farley on that "Saturday Night Live" sketch ("awesome").

Anyway, I still get goose bumps thinking about it, and I will never forget it.

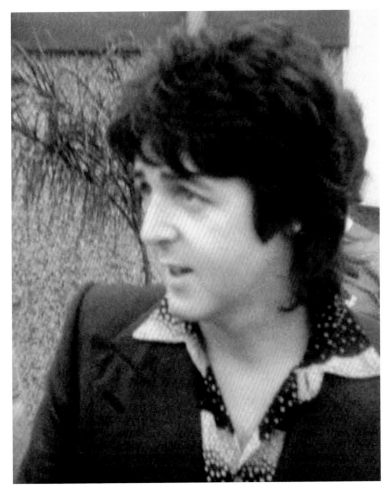

Photo by Guy Duplantier

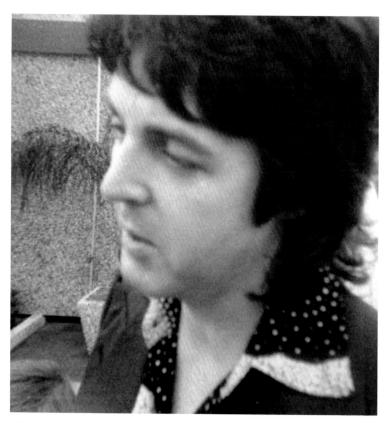

Photo by Guy Duplantier

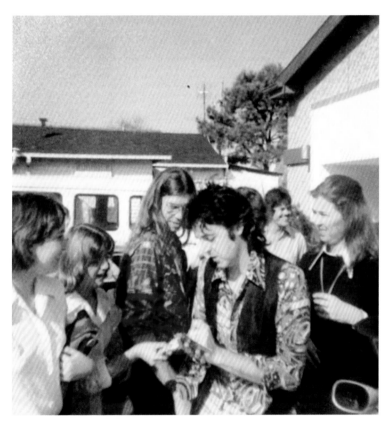

Paul signing for fans, by Guy Duplantier

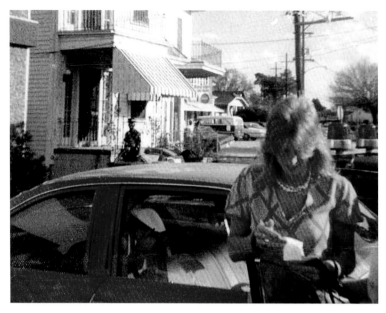

Linda, by Guy Duplantier

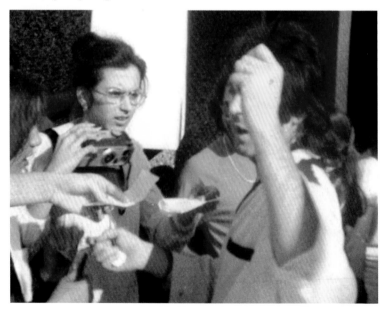

Paul chatting with fans, by Guy Duplantier

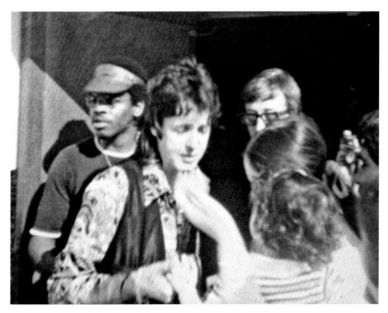

Photo by Guy Duplantier

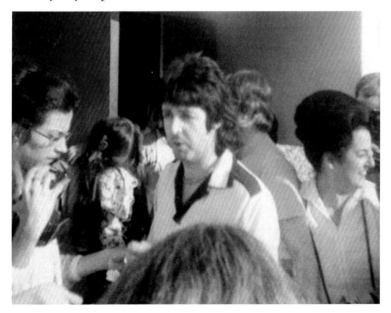

Photo by Guy Duplantier

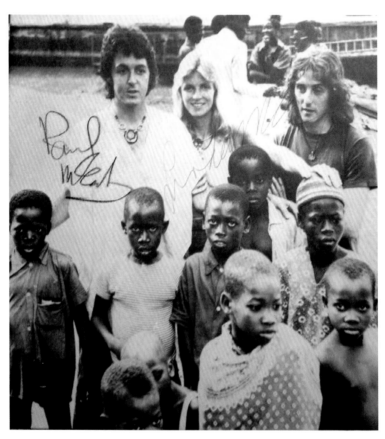

The inner sleeve to Guy Duplantier's Band on the Run *album, signed by Paul and Linda*

BEATLEMANIAC

Steve Harris

My first remembrance of the Beatles was when they first appeared on "The Ed Sullivan Show" in 1964, which I watched regularly. I was just a kid at the time and not much of a music fan, but I loved the songs of the Beatles.

My friend and fellow Beatlemaniac, Richard Keen, and I heard that Paul McCartney would be recording an album at Sea-Saint Studio in January of 1975. Of course, we had to go in person to check it out. We went to the studio one afternoon and were surprised to see that there were only two other people waiting in the parking lot for Paul to appear. We didn't have long to wait until Paul drove up, by himself. I naturally expected him to just hurriedly shake hands and run into the studio, but he spent some time outside talking to us and letting us take pictures. It probably wasn't more than five or ten minutes, but it seemed a lot longer. I really don't remember anything that was said. I was in shock and only recall that my knees were shaking. I felt as though I could hardly stand up.

We returned to the studio many times, and of course as the days passed, the crowd kept growing. We eventually met Linda, as well as Denny Laine and Jimmy McCulloch. We got

autographs from them all. Linda was especially nice and spent a lot of time talking to us whenever Paul was surrounded by hordes of schoolgirls.

I have met several famous people since then, but none was anywhere near as friendly as Paul and Linda. And none of them made me feel weak in the knees either.

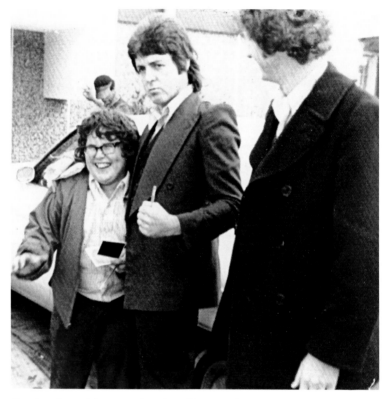

Paul posing with young fan Frankie Macaluso (left) and Steve Harris

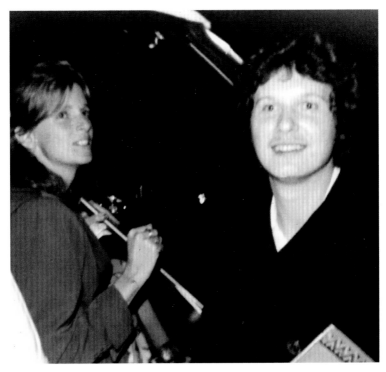

Linda sitting in the car holding one of Paul's guitars, pictured with Steve Harris

A BEATLE IN PERSON

Val Bethancourt

My first exposure to the Beatles occurred on January 3, 1964. My dad and I were watching television on a Friday night, and a film clip was shown on "The Jack Parr Show" of the Beatles playing "She Loves You." I was eleven years old. This clip was actually shown as a joke, making fun of the reaction of the girls screaming and carrying on in the audience. One month later, the Beatles appeared on "The Ed Sullivan Show," and the rest is history.

On September 16, 1964, my older sister, Jan, watched the Beatles perform live at City Park Stadium in New Orleans. She still has her five-dollar ticket stub. Well, I finally got my chance to see a Beatle in person when Paul McCartney came to New Orleans in 1975 to record the *Venus and Mars* album at Sea-Saint Studio.

My friend John Taylor, who already met Paul outside the studio several times, told me to come either at noon or midnight and I might get to meet him too. I decided to go late one night in February, after watching a Mardi Gras parade. I brought a *Life* magazine from April 1971 with Paul and Linda on the cover, in hopes of getting it autographed.

Around midnight, the door to the studio opened, and to

Val Bethancourt's Life *magazine cover, signed by Paul and Linda*

my amazement, Paul and Linda came walking out. I showed
Paul the magazine and asked for their autographs. They gladly
obliged.

My luck continued. A few minutes later, my friend John
snapped a photo of Paul and me, just before Paul ducked into
his car and drove off with Linda. That is a night I will always
remember.

My dad had predicted that the Beatles wouldn't last two years. I never did let him live that down.

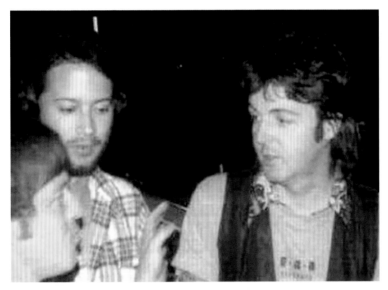

Val (center) and Paul

MARDI GRAS

John Taylor

Paul, Linda, their children, and members of Wings spent Mardi Gras Day in an apartment above Kolb's restaurant. They could watch the parades from the balcony overlooking the street. Paul and Linda were disguised as clowns.

I was in the street below. Paul and Linda recognized me from the studio, and we played pitch and catch with strings of Mardi Gras beads. Heather McCartney was watching the parades from downstairs and stood right next to me.

Skelly Tempereau

Back in 1975, when I was a carefree young girl, I fulfilled the dream of a lifetime. Backstage at a Dr. John concert, I had the distinct pleasure of meeting the band members of Wings. Paul and Linda were recording *Venus and Mars* in New Orleans. I just so happened to know Marshall Sehorn, a longtime record producer and co-owner with Allen Toussaint of Sea-Saint Studio. My friend, Carla, and I somehow landed backstage as a result of that relationship.

Carla and I immediately recognized the diminutive Jimmy

McCulloch during that concert, but there was no way we were going to approach him. The last thing we wanted to do was come off like two groupies waiting to pounce. Remarkably, he approached us and asked if we would kindly show the entourage where the "locals" hung out in the wee hours of the morning. The entire band, sans Paul and Linda, wound up in an all-night spot for breakfast. After bidding them a good night, Carla and I staggered home at the break of dawn.

Coincidentally, I was acquainted with a photographer who was assigned to capture photos of Wings and the McCartney family during their New Orleans stay. On Lundi Gras (the night before Mardi Gras Day), I received an invitation to spend the next day with Paul McCartney at a second-floor apartment above Kolb's restaurant. This restaurant, located on St. Charles Street near Canal Street and the French Quarter, overlooked the parade route. Of course, I jumped at this chance but had no idea that this Mardi Gras Day would become one of the most unforgettable experiences of my life.

We were greeted by Paul, in full dress as a clown, and were guided upstairs, where approximately thirty people were gathered for the day's festivities. I did not know most of them (I suspect they were muckety-mucks in the music biz), but I immediately recognized Linda and the kids. I was introduced to all and was surprised that some members of Linda's family were there.

Paul was incredibly gracious and very easy to talk to. He was drinking scotch and milk, if I'm not mistaken. So, as the day went on, fun was obviously had by all.

The only issue was that even though Paul and Linda were

in costume, a crowd started to gather on the street. Either word got out that the McCartney party was there, or people recognized the group, even with the makeup and costumes. Sadly, due to the lack of privacy, it seemed little Heather, Mary, and Stella McCartney would not be able to participate in the fun. Still, Paul and I agreed that the kids should not miss out on the parade experience.

Needless to say, I was honored when Paul and Linda entrusted me to take their children to the parade. As a result, the kids and I had the best time ever. At the end of the day, Paul thanked me over and over for helping the children experience one of New Orleans' biggest days of the year. They were able to feel like native New Orleanians, and I had a story to tell my grandchildren or anyone else who will listen.

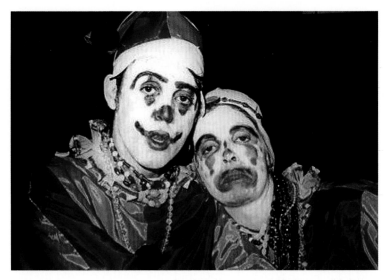

Paul and Linda on Mardi Gras Day. Photo by Sidney Smith / http://www.sidneysmithphotos.com/.

I saw the Wings members and crew a couple of times before they completed their recording. Being a child of the sixties, I felt that meeting Paul McCartney was like a dream, but I must admit that he was nothing like the superstar that he's perceived to be. He was just a dad enjoying the celebration that we and our families are able to experience every year.

Mark Campbell

Growing up, I lived in an apartment above Kolb's restaurant. My mother, Juanita, and stepfather, Bill Martin, managed and operated Kolb's for eight years or so, until his death in 1977. Whenever I came off the road, or even if I lived in town and didn't feel like driving to my house, they always had my old room ready for me.

In 1975, I was on the road with the band Cross. I believe that we were in Athens, Georgia, and it was just another Tuesday there. I got homesick and called my mom to say happy Mardi Gras.

She said, "Guess who's here. And they're using your bed to throw their coats on." It was Paul McCartney and Wings. *Argh!* Then my friend, Steve Howard, got on the phone just to rub it in. He and I had worked together for a couple of years at the Ivanhoe club, with the band Sugardaddy. This was too cruel!

Apparently, since there was nowhere for Wings to see the parades safely, Allen Toussaint, co-owner of Sea-Saint Studio, and Paul's manager had contacted Bill. So Bill offered up our home, for a price, ha ha ha!

My French doors opened up to the balcony that they were all standing on. Big-time bummer!

Author's Note: Mark Campbell is the lead singer for the California-based band Jack Mack and the Heart Attack. He and I were in a group together in 1969.

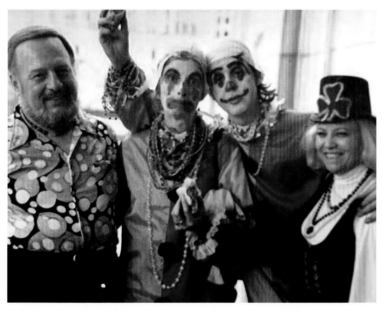

Bill and Juanita Martin, flanking Linda and Paul; photo courtesy of Mark Campbell

DELTA 88

John Taylor

The car that Paul used while staying in New Orleans was a white Oldsmobile Delta 88 convertible. He and Linda drove around the city without any escort. I can only imagine the reaction of some people when they looked at the car next to them and saw Paul McCartney.

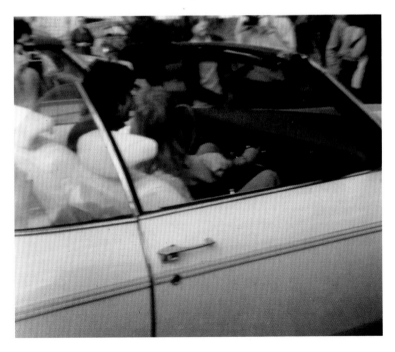

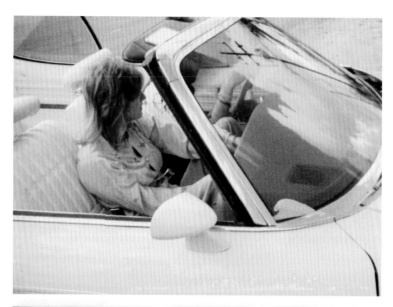

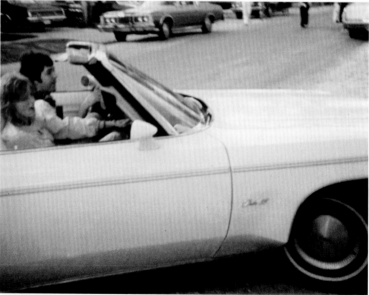

Paul and Linda arriving at the studio in the Oldsmobile Delta 88 convertible

Warren (Jimmy) Jacob

I lived in Gentilly close to Sea-Saint Studio and went there many times when Paul was there. I saw him quite a few times but never got to meet him.

One day, I was driving down Jefferson Highway just past the Orleans Parish line when a train was crossing. The traffic was stopping, and all of a sudden, a white convertible Oldsmobile rolled passed me, with none other than Paul and Linda McCartney inside. I couldn't believe it at first.

I got out of my car, walked up to the driver's side, shook Paul's hand, and introduced myself. He, in return, introduced himself and his wife. We laughed.

To my surprise, he was very friendly. He explained he was just riding around enjoying the city and expressed how much he loved New Orleans. He was a very down-to-earth person. He also mentioned he was recording at Sea-Saint.

The train passed, and I said goodbye and how much of a pleasure it was meeting them. They both said goodbye and that was it. That was my experience with Paul McCartney.

It was a great moment for me, since I was playing bass guitar in bands back then, and my very first one was a Paul McCartney bass. I mentioned this to him, and he jokingly said if he ever needed a bass player, he'd call me.

Jacquelyn Jackson

I had just moved to the corner by Clematis Street and found out there was a big recording studio a few houses away. Some

of my new friends, who were musicians, lived across from Sea-Saint Studio and told me Paul McCartney was going to be coming to the studio the next week to record an album. From then on, I was on the lookout for him. I met Allen Toussaint a few days later, and he told me it was true. He told me what day McCartney would be there for the first time. When he came, I was sitting outside, just hanging out. I was in awe! I sat outside that studio the rest of the day and most every day after that.

After a few days, about five of us were always there. Paul started saying hello to us, and then he came over and began talking to me and another person who was always there. I was talking to Paul McCartney! I asked him if I could kiss him, and he said yes. It was a quick smack on the lips. Wow!

About three weeks later, word got out that he and Wings were at the studio, and the crowd started building. We original five always had our sitting spot near the main entrance. The other front door went right into the studio and was hardly ever used.

I was going to the University of New Orleans in the mornings. Since McCartney never showed up until around three, it was easy for me to go to school and then hang at the studio and do my homework there. One day, I got off the bus on Elysian Fields and started walking home. Paul turned the corner in a car, stopped, and asked if I would like a ride to the studio. Well, hell yes! They all knew my name by then. I got in the car and told him I was so glad I didn't miss him.

When we pulled up to the studio, a news crew was waiting to interview Paul. We got out of the car, and the crew ran up to him. They asked him a couple of questions. Then he said, "Jackie, come here."

I went over there and the reporter started interviewing me as I stood next to Paul. I will never forget it. They asked, "How long have you been a fan of Paul McCartney's?" I said, "I have been a fan of Paul McCartney's as long as I can remember. I grew up with him." He looked at me and said, "Funny, I grew up with him too." I knew then that was about the dumbest thing I could have said. It's funny how clearly you remember your embarrassing moments.

Then it was time for him to go into the studio—without me, of course—and he kissed me on my cheek in front of the TV camera. Needless to say, everyone wanted to know who I was. I was just a fan who got a ride.

Figaro, a free weekly entertainment magazine that came out in New Orleans, published a story the next week about Paul McCartney and Wings being at the studio. It included a paragraph about a groupie who was hanging with him and rode with him to the studio. I was far from a groupie, but my friends knew who the article was talking about. It was so much fun at school after the interview on TV and the article, because everyone thought I was his good friend. Not even close. He did tell me I reminded him of Linda—blonde hair cut like hers, I guess—but nope, I was just a fan.

The last week that Wings was there, I finally got to go inside and listen to a couple of the songs they were recording. I actually got to hang out with the guy whose poster had been on my wall when I was a young girl.

I wound up quitting college that semester; it was just so exciting to be a part of what was happening at the studio. You never knew who was going to show up. That was the

beauty of living by that studio. One day Patti Labelle might be strolling to the Capitol Grocery a half-block away, or Keith Richards might be playing guitar in a car, or Eric Clapton might be walking in to do some work on someone's album, or Clint Eastwood might be recording voiceovers for a movie he filmed here. Yep, it was too exciting to go to school. I did finish years later. I was forty when I got a degree.

A twelve-year-old boy named Frankie Macaluso lived down Clematis Street. His parents would drop him off at the studio after school and come get him when it got dark. Paul and Linda really liked Frankie.

I lost all my photos from that time in Hurricane Katrina, but I still know a lot of people who remember it.

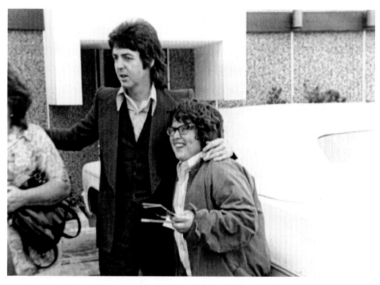

Paul with twelve-year-old Frankie Macaluso. They tried to convince Frankie's mom to get in the picture, but she ducked out. Photo courtesy of John Taylor.

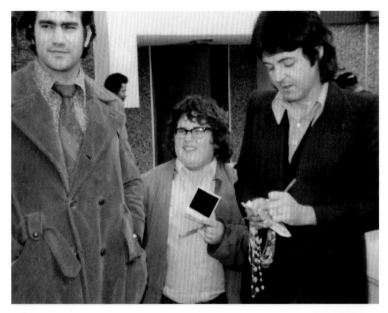

John Taylor, Frankie Macaluso, and Paul; photo courtesy of John Taylor

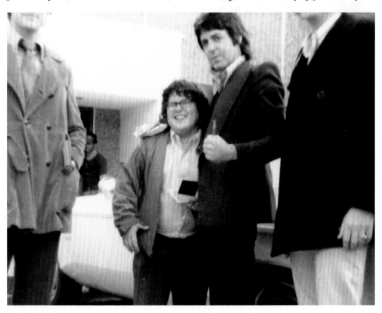

John Taylor, Frankie Macaluso, Paul, and Steve Harris; photo courtesy of John Taylor

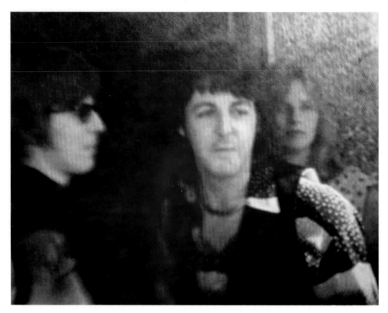

Photo by Maureen Rouse Hudson

REFLECTING BACK

Meeting Paul and Linda was definitely a major event in my life. The biggest shock was that they were not the least bit arrogant, though they had every right to be. They were as down to earth and friendly as could be. They sincerely cared about their fans. They would pose for pictures and sign things without any hesitation. I even asked Linda if I could put my arm around her for one picture, and she replied, "Sure." They treated us as though we were close friends, and I will always respect them for that. Paul McCartney was part of the group that changed music, style, and Western culture. He is probably the most successful musician, singer, and songwriter in the world. And yet, he and his wife took time out of their busy lives for a few fans. Thank you, Paul and Linda.

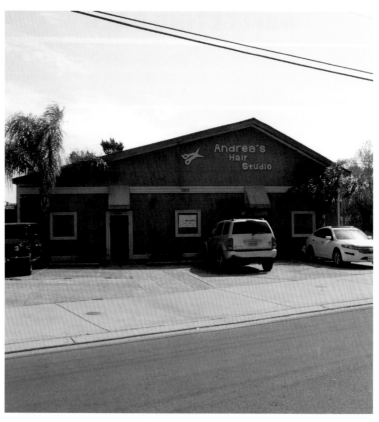

Sea-Saint Studio as it appears today